Robert Doisneau

로베르 두아노

마로니에북스 TASCHEN

ROBERT DOISNEAU (1912–1994)

Robert Doisneau continues to tell stories full of feeling, poetry and humour, and to enchant us with his capacity to communicate that implicit but fleeting relationship – a tender complicity – that made him one with what he photographed. Born in Gentilly on 14 April 1912 between 'Bièvres' and the now vanished fortifications, just outside Paris, Doisneau remained a denizen of the suburbs till his death: the Montrouge apartment that he took in 1937 remained his home for the rest of his life. The particular interest he took in working-class milieux and environments led to images rich in poetic social realism, images that profoundly influenced the film and literature of his time. In 1950, the magazine *Life* commissioned a set of images of the lovers of Paris from the agency Rapho. The result was the famous series of 'Kisses', including the 'Baiser de l'Hôtel de Ville', which has become Doisneau's signature image. The 'Kisses' were for the most part staged, but display a wonderful complicity with the participants in this typically Parisian theatre. Always the loner, Doisneau has continued the rounds of his own chosen area between Paris, Montrouge and Gentilly and there are now more than 400.000 pictures to testify to his perambulations and discoveries. He is the true *piéton de Paris*.

Robert Doisneau hat uns unablässig seine Geschichten erzählt, Geschichten voller Poesie und Humor, besaß er doch diese unvergleichliche Begabung, seine einfühlsame Komplizenschaft zu vermitteln, diese tiefe und zugleich rasch vergängliche innere Beziehung, die ihn mit dem jeweiligen Motiv seiner Fotografie verband. Robert Doisneau wurde am 14. April 1912 in Gentilly im geboren, nur wenige Kilometer von Paris entfernt, und er sollte sein Leben lang Vorstadtbewohner bleiben. Seine Wohnung in Montrouge, die er 1937 bezog, sollte er nie wieder aufgeben. Sein ausgeprägtes Interesse am Milieu der einfachen Leute hat es ihm ermöglicht, Bilder zu schaffen, die von einer Art poetischem Realismus sind, der das Kino und die Literatur jener Zeit stark beeinflusst hat. Im Jahr 1950 erhielt die Agentur Rapho von der Zeitschrift *Life* den Auftrag, Fotoillustrationen über die Liebenden von Paris zu liefern. Daraus entstand die berühmte Serie der „Küsse", zu denen auch der *Kuss vor dem Rathaus* gehört. Es sind überwiegend inszenierte Bilder, doch sie zeugen von einer selten gesehenen Komplizenschaft mit den Darstellern dieses hübschen und für Paris so typischen Spiels. Stets als Einzelgänger hat Doisneau unablässig sein kleines, genau abgegrenztes Territorium zwischen Paris, Montrouge und Gentilly durchwandert, und mehr als 400 000 Aufnahmen zeugen heute von den Wanderungen und Entdeckungen des Mannes, der immer der einzig wahre Fußgänger von Paris bleiben wird.

Robert Doisneau n'a cessé de nous raconter des histoires pleines de sentiments, de poésie et d'humour en nous enchantant par sa capacité à transmettre cette tendre complicité, cette relation implicite et fugace qui l'unit avec celui qu'il photographie. Né à Gentilly le 14 avril 1912 entre « Bièvres » et « fortifs », à deux pas de Paris, Doisneau restera banlieusard jusqu'à sa disparition puisqu'il ne quittera jamais cet appartement de Montrouge où il emménage un beau jour de 1937. Son intérêt privilégié pour les milieux populaires et leurs décors de vie, lui a permis de réaliser des images imprégnées d'un certain réalisme poétique social qui a profondément marqué, par ailleurs, le cinéma et la littérature de l'époque. En 1950, le journal *Life* transmet à l'agence Rapho une commande d'images illustrant les amoureux de Paris. C'est la fameuse série des « Baisers » dont fait partie celui de l'Hôtel de Ville. Des images pour la plupart mises en scène mais qui témoignent d'une rare complicité avec les acteurs de ce petit jeu typiquement parisien. Toujours en solitaire, Doisneau n'a cessé de parcourir son petit périmètre bien délimité entre Paris, Montrouge et Gentilly et plus 400 000 clichés témoignent aujourd'hui des déambulations et des découvertes de celui qui reste le véritable piéton de Paris.

로베르 두아노는 감정과 시, 유머로 가득 찬 이야기를 우리에게 들려준다. 그는 다정한 공모(共謀) 관계, 즉 자신과 피사체를 하나로 만들어주는 암묵적이며 일시적인 관계를 전달하는 능력으로 우리를 매혹한다. 두아노는 1912년 4월 14일 장티이에서 태어났다. 이곳은 파리에서 아주 가까운 곳으로, '비에브르'와 지금은 사라진 요새 사이에 있다. 두아노는 1937부터 살기 시작한 몽루주의 아파트를 한 번도 떠난 적이 없으며, 평생 교외에서 살았다. 서민층과 그 생활환경에 특히 관심이 많았기 때문에, 그의 사진에는 시적인 사회사실주의의 분위기가 배어 있다. 이런 성향은 당대의 영화와 문학에 깊은 영향을 끼쳤다. 1950년, 『라이프』지는 파리의 연인들을 담은 사진을 찍어줄 것을 라포 에이전시에 의뢰했다. 이것이 바로 유명한 '키스' 연작이며, 〈시청 앞의 키스〉도 그 중 하나이다. '키스' 연작은, 대부분 연출된 것이지만, 파리를 무대로 살아가는 사람들의 전형적인 모습을 보여준다. 늘 고독하게 지냈던 두아노는 파리와 몽루주, 장티이로 한정된 자신만의 작은 구역을 끊임없이 오갔다. 그리고 오늘날 남아 있는 40만 장 이상의 사진이 그가 어느 곳을 다녔고 무엇을 발견했는지를 증명한다. 그는 진정한 파리의 보행자였다.

ドアノーは、情感と詩とユーモアのこもった物語を語り、その被写体と会話する独特の能力で我々を魅了し続ける。それは彼と被写体とを一体にしている、もろい絆とも言うべき、そこに含蓄されそのときだけしか存在しないかかわりだ。1912年4月14日にパリの郊外、ビエイブルと、今はなくなってしまった城壁との間に挟まれたジョンティイに生まれたロベール・ドアノーは死ぬまで、このパリ郊外に住み続けた。1937年に借りたモンルージュのアパルトマンは生涯彼のすみかとなったわけだ。労働者階級の環境にとりわけ関心を示したことから、詩的にも社会的にもリアリズムの色濃い写真が生まれ、彼の時代の映画や文学にも多大な影響を与えた。1950年に『ライフ』誌がパリの恋人たちの写真をラフォ通信に依頼した。その結果生まれたのが、かの有名な「キス」シリーズで、中でも《パリ市庁舎前のキス》はドアノーの代表作となった。「キス」シリーズは、その大半は演出されたものだが、この典型的なパリっ子劇場における素晴らしい協力関係を参加者との間に築いた。常に単独行動をするドアノーは、パリとモンルージュ、ジョンティイの好みの場所を歩き回り、その証拠となる写真は今では40万枚以上に上る。彼は本当の意味での「パリをさすらう人」であろう。

포트폴리오
로베르 두아노

발행일: 2006년 3월 1일
펴낸이: 이상만
펴낸곳: 마로니에북스
등록: 2003년 4월 14일 제2003-71호
주소: (110-809) 서울시 종로구 동숭동 1-81
전화: 02-741-9191(대)/편집부 02-744-9191/팩스 02-762-4577
홈페이지 www.maroniebooks.com

ISBN 89-91449-35-2 (SET 89-91449-69-7)

Robert Doisneau: Portfolio
© 2006 TASCHEN GmbH
Hohenzollernring 53
D-50672 Köln
www.taschen.com

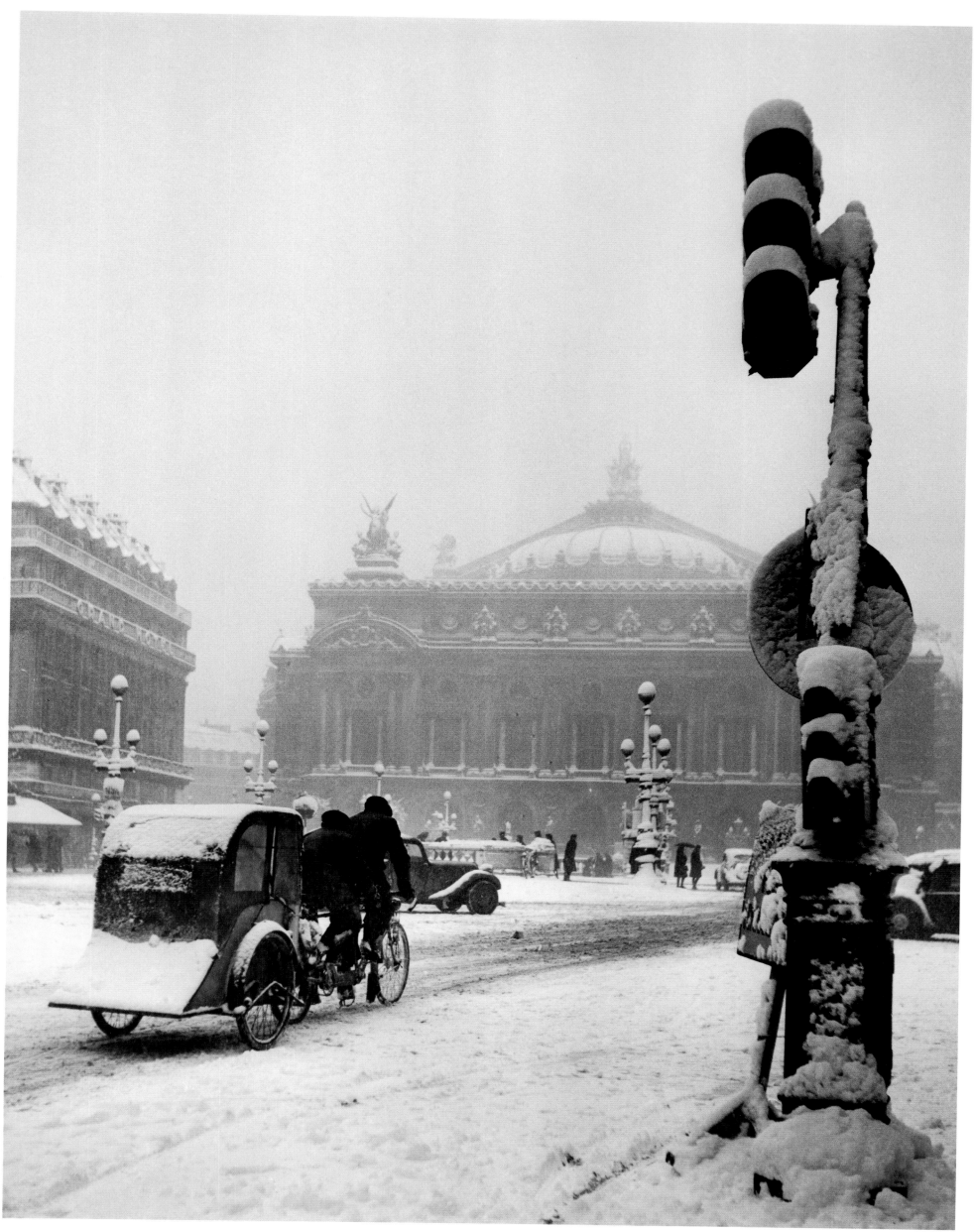

로베르 두아노 **자전거 택시,** 1942년

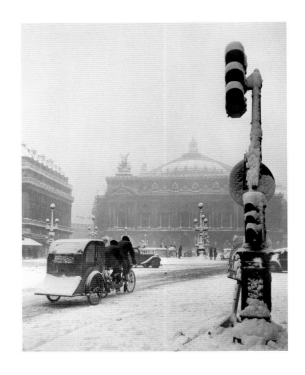

Robert Doisneau
Rickshaw-Taxi, Avenue de l'Opéra, Paris 2ᵉ, 1942
Fahrrad-Taxi
Vélo-taxi
자전거 택시
自転車タクシー

"I never noticed time passing, I was too taken up with the spectacle afforded by my
contemporaries, that gratuitous, never-ending show for which no ticket is needed, and when the
occasion arose, I offered them, in passing, the ephemeral solace of an image".

„Ich habe die Zeit nicht verstreichen sehen, zu sehr war ich mit dem unaufhörlichen Schauspiel
beschäftigt, das mir von meinen Zeitgenossen bereitet wurde, und die ich dafür ... mit einem fast im
Vorübergehen geschaffenen Bild entschädigte".

« Je n'ai pas vu le temps passer, trop occupé que j'étais du spectacle permanent et gratuit offert
par mes contemporains, les soulageant, quand l'occasion se présentait, d'une image au passage. »

"나는 시간이 흘러간다는 것을 느껴보지 못했다.
나는 같은 시대를 사는 사람들이 공짜로 보여주는 끝없는 광경에 너무나 정신이 팔려 있었다.
그리고 기회가 생기면 덧없는 이미지로써 그들에게 위안을 주었다."

「私は時のうつろいを感じたことはない。周りが見せてくれる壮大な光景に目を奪われて、
それどころじゃないんだ。決して終わることのない、このショーを見るにはチケットも要らないしね。
そして機会があれば、写真というつかの間の慰めを皆さんに提供するんだ」

ROBERT DOISNEAU

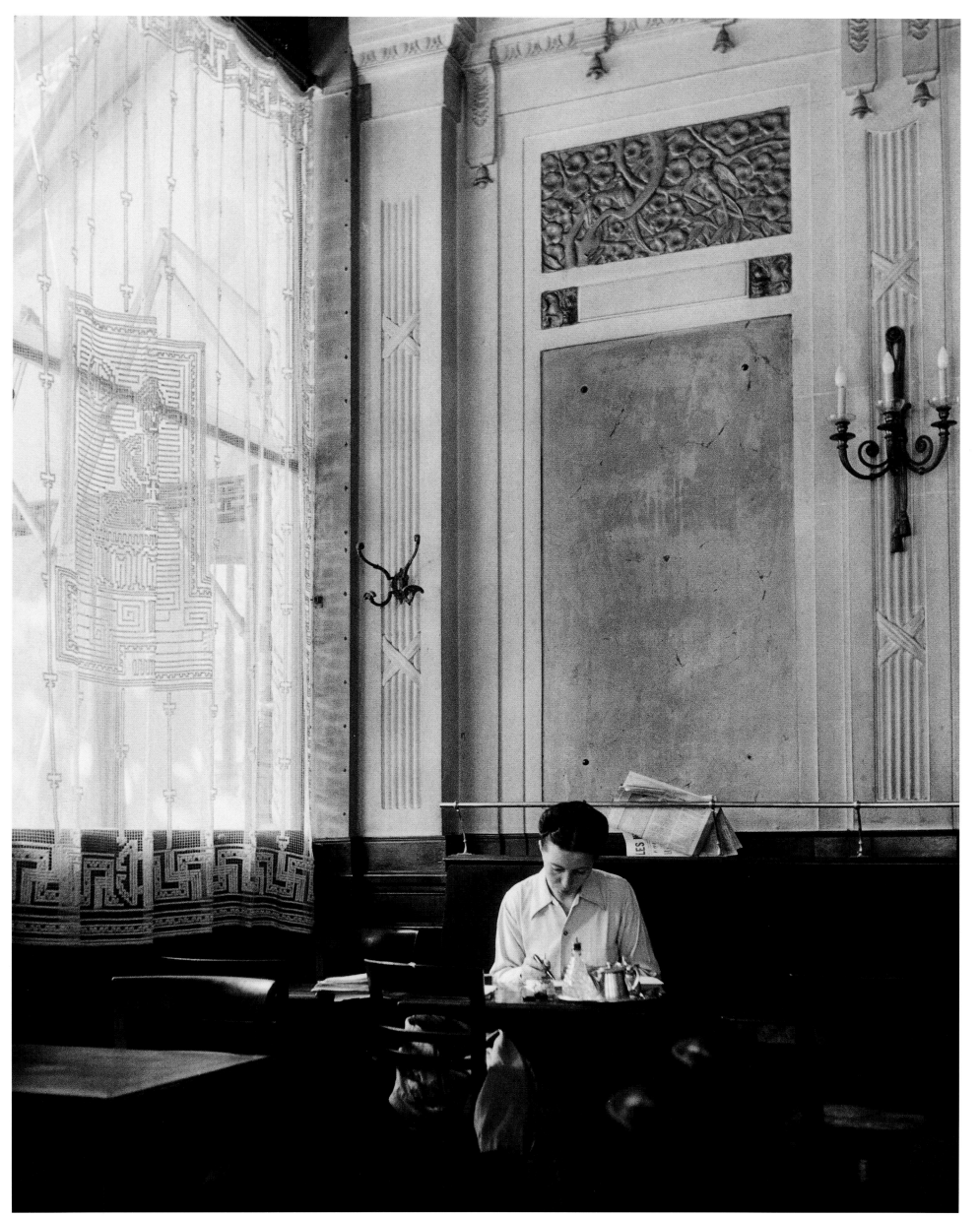

로베르 두아노 '되 마고'의 시몬 드 보부아르, 1944년

Robert Doisneau
Simone de Beauvoir at the "Deux Magots", Paris 6ᵉ, 1944
Simone de Beauvoir im „Deux Magots"
Simone de Beauvoir aux « Deux Magots »
'되 마고'의 시몬 드 보부아르
シモーヌ・ドゥ・ボーボワール "ドゥ・マゴ" にて

"There are days when simply seeing feels like happiness itself …
You feel so rich, the elation seems almost excessive and you want to share it".

„Es gibt Tage, da empfindet man die einfache Tatsache des Sehens wie ein wahres Glück …
Man fühlt sich so reich, dass man Lust bekommt, den übergroßen Jubel mit den Anderen zu teilen."

« Il est des jours où l'on ressent le simple fait de voir comme un véritable bonheur … On se sent si riche
qu'il nous vient l'envie de partager avec les autres une trop grande jubilation. »

"본다는 단순한 일이 진정한 행복으로 느껴지는 날들이 있다…….
너무 충만한 느낌이 들어서 그 엄청난 기쁨을 다른 사람들과 나누고 싶다는 생각이 든다."

「ただ見ることそれ自体が幸せそのものに感じられる日もある…とても豊かに感じられ、
その喜びが溢れんばかりになって、誰かと分かち合いたくなるんだ」

ROBERT DOISNEAU

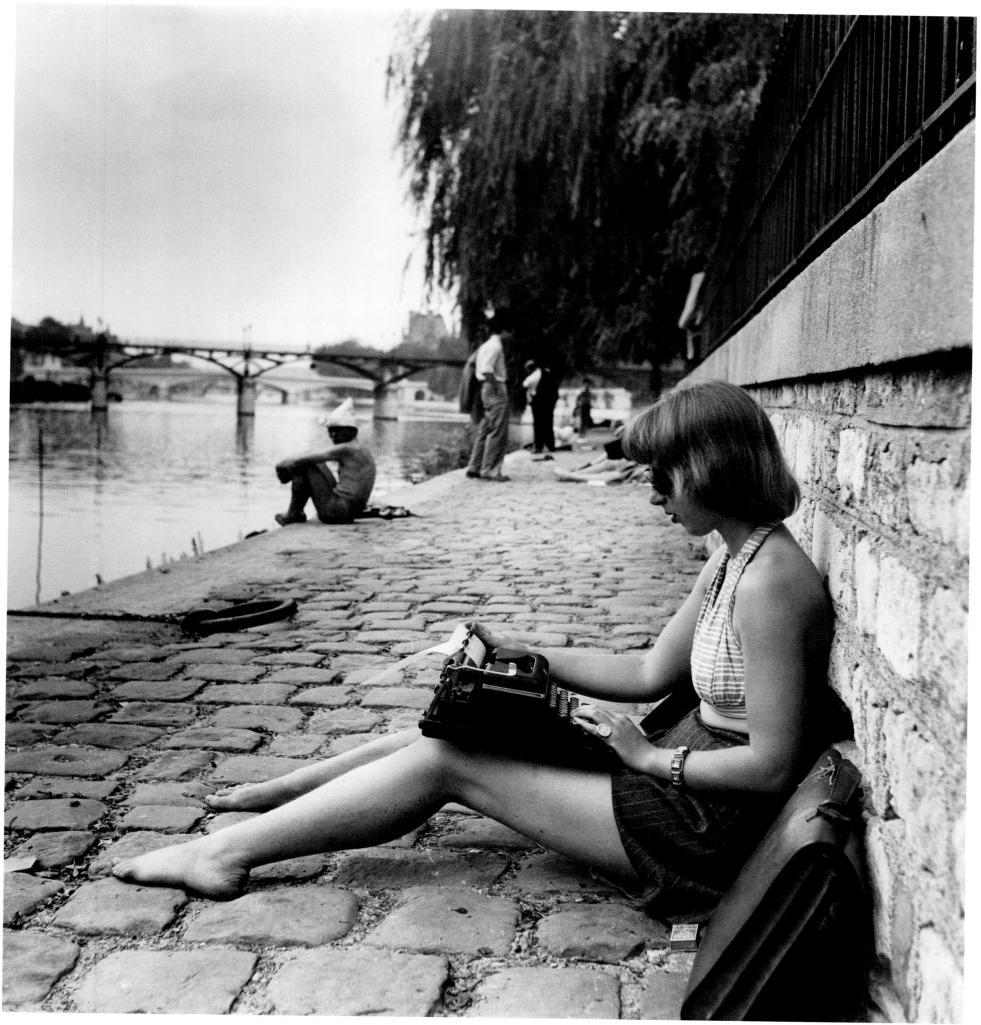

로베르 두아노 **타이피스트**, 1947년

Robert Doisneau
Typist, Square du Vert-Galant, Paris 1er, 1947
Die Schreibkraft
Dactylo
타이피스트
タイピスト

"When it comes down to it, constraint's no bad thing. My shyness censored me,
and I took people only from a distance. As a result, there was space all around them,
and this was something I tried to get back to ..."

„Letztlich hat die Beschränkung auch eine gute Seite. Diese mir durch die Schüchternheit auferlegte
Zensur, die mich die Leute nur von weitem aufnehmen ließ, sorgte auch für den Raum um sie herum,
den ich in der Folgezeit immer wieder herzustellen versuchte..."

« Finalement, la contrainte a du bon. Cette censure imposée par la timidité, en me faisant
prendre les gens de loin, donnait tout autour cet espace que j'ai cherché à retrouver par la suite ... »

"결국, 제약에도 좋은 점이 있다. 나는 수줍음 때문에 멀찍이 떨어져서 사람들을 찍는다.
그러면 그들 주위에는 온통 공간이 생기는데, 그 공간이야말로 내가 찾던 것이다."

「考えようによっては、恥ずかしがりも悪いものではない。内気な性格のせいで、
人を撮るときは距離をおいた。結果として、被写体の周りにスペースが生まれ、
これこそが私が撮りたいと思っていたものだったのだ」

ROBERT DOISNEAU

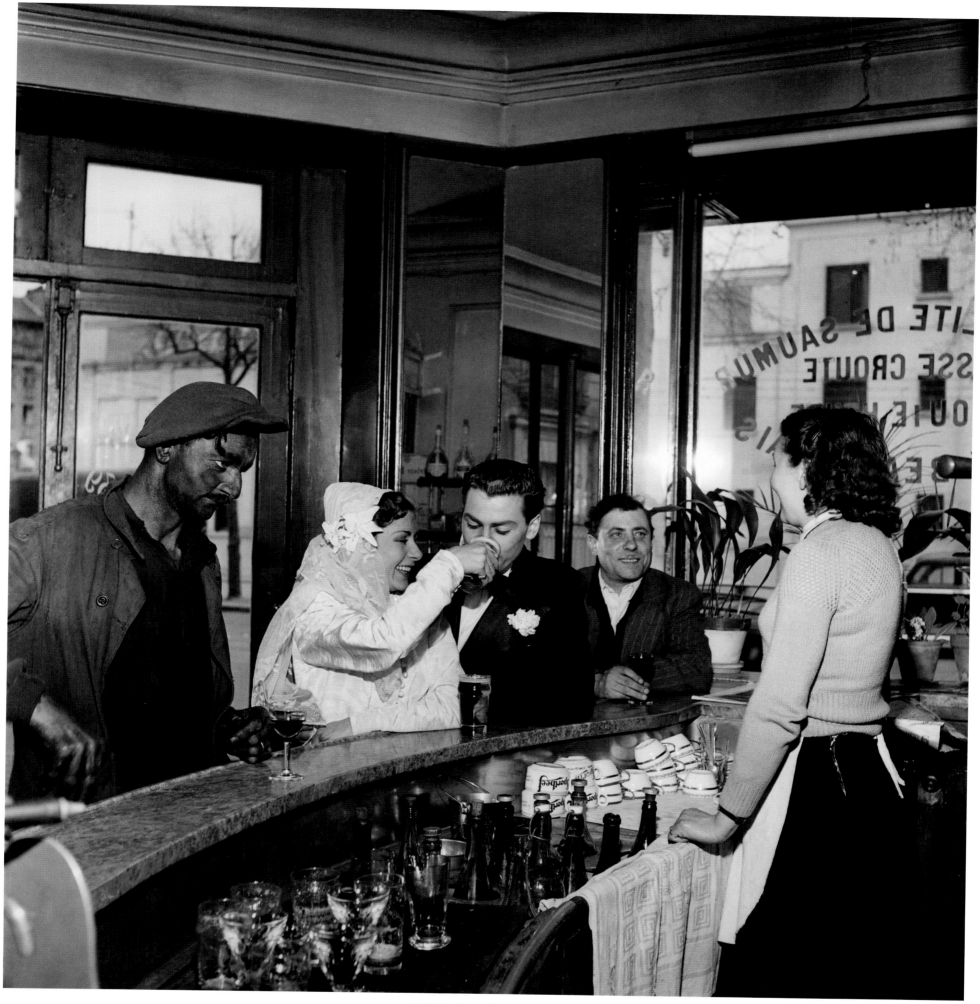

로베르 두아노 **흑백 카페**, 1948년

Robert Doisneau
Black and White Café, Joinville-le-Pont, 1948
Schwarzer Kaffee mit Sahne
Café noir et blanc
흑백 카페
黒と白のカフェ

"I know every step of the way from Montrouge to the Porte de Clignancourt. I can't go 400 yards without coming across someone I know: a bistrot-owner, a carpenter, a printer, a painter or just someone off the street".

„Ich kann von Montrouge bis zur Porte de Clignancourt gehen. Mindestens alle 400 Meter treffe ich einen Bekannten: den Inhaber eines Bistros, einen Kunsttischler, einen Drucker, einen Maler oder ganz einfach einen Typen, den ich auf der Straße kennen gelernt habe."

« Je peux aller de Montrouge à la Porte de Clignancourt en pointillé. Pas plus de 400 mètres à faire sans rencontrer quelqu'un de connaissance : un patron de bistrot, un ébéniste, un imprimeur, un peintre ou simplement un type de la rue. »

"나는 몽루주에서 포르트 드 클리냥쿠르까지 가는 길을 속속들이 알고 있다.
400미터도 채 안 되는 거리인데도 지날 때마다 아는 사람과 마주친다.
레스토랑 주인, 가구세공인, 인쇄업자, 화가 혹은 그냥 거리를 지나가는 사람이라도 만나게 된다."

「モンルージュからポルト・ドゥ・クリニャンクールに至る道の隅々まで知っているよ。
知人に出くわさずに400ヤードと歩けないね。ビストロのオーナー、大工、印刷屋、ペンキ屋、
それに裏道に入っても誰かに会ってしまうよ」

ROBERT DOISNEAU

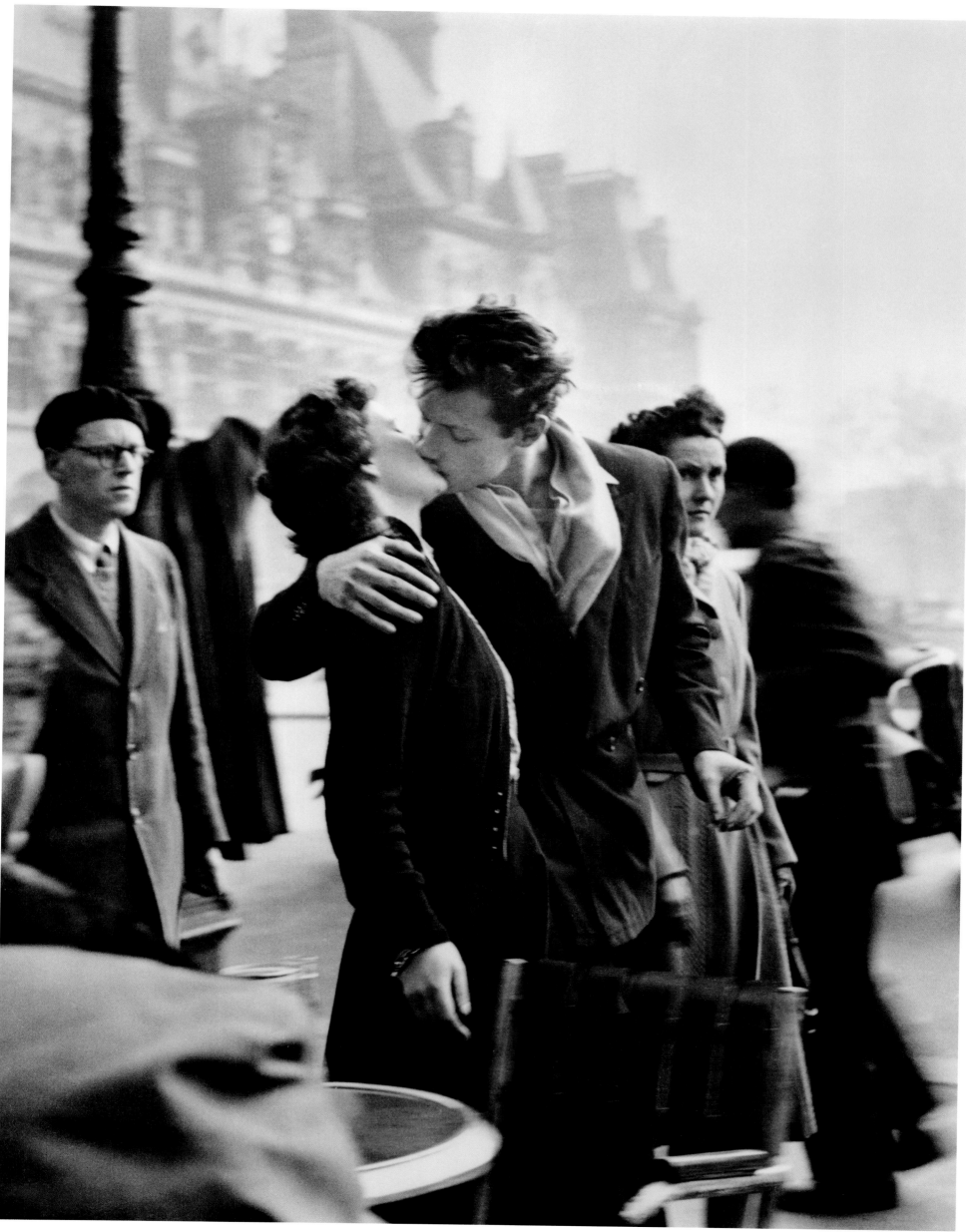

로베르 두아노 **시청 앞의 키스**, 1950년

Robert Doisneau
Le Baiser de l'Hôtel de Ville, Paris 4ᵉ, 1950
Der Kuss vor dem Rathaus
Le Baiser de l'Hôtel de Ville
시청 앞의 키스
パリ市庁舎前のキス

"Disobedience seems a vital function to me, and I must say I haven't missed many opportunities for it."

„Ungehorsam scheint mir eine lebensnotwendige Funktion zu sein, und ich muss zugeben,
dass ich ihn mir nicht verkniffen habe."

« Désobéir me paraît une fonction vitale, et je dois dire que je ne m'en suis pas privé. »

"위반(違反)은 내게 아주 중요한 것 같다. 그것 때문에 기회를 놓친 적은 그리 없었다."

「不服従は私の根本的な性格のようで、そのことで多くのチャンスを逃したことはない、ということを、
はっきりと述べておきたい」

ROBERT DOISNEAU

© 2006 TASCHEN GmbH
Hohenzollernring 53, D-50672 Köln
www.taschen.com
© 2004 Atelier Robert DOISNEAU

Korean Translation © 2006 Maroniebooks, Seoul
www.maroniebooks.com

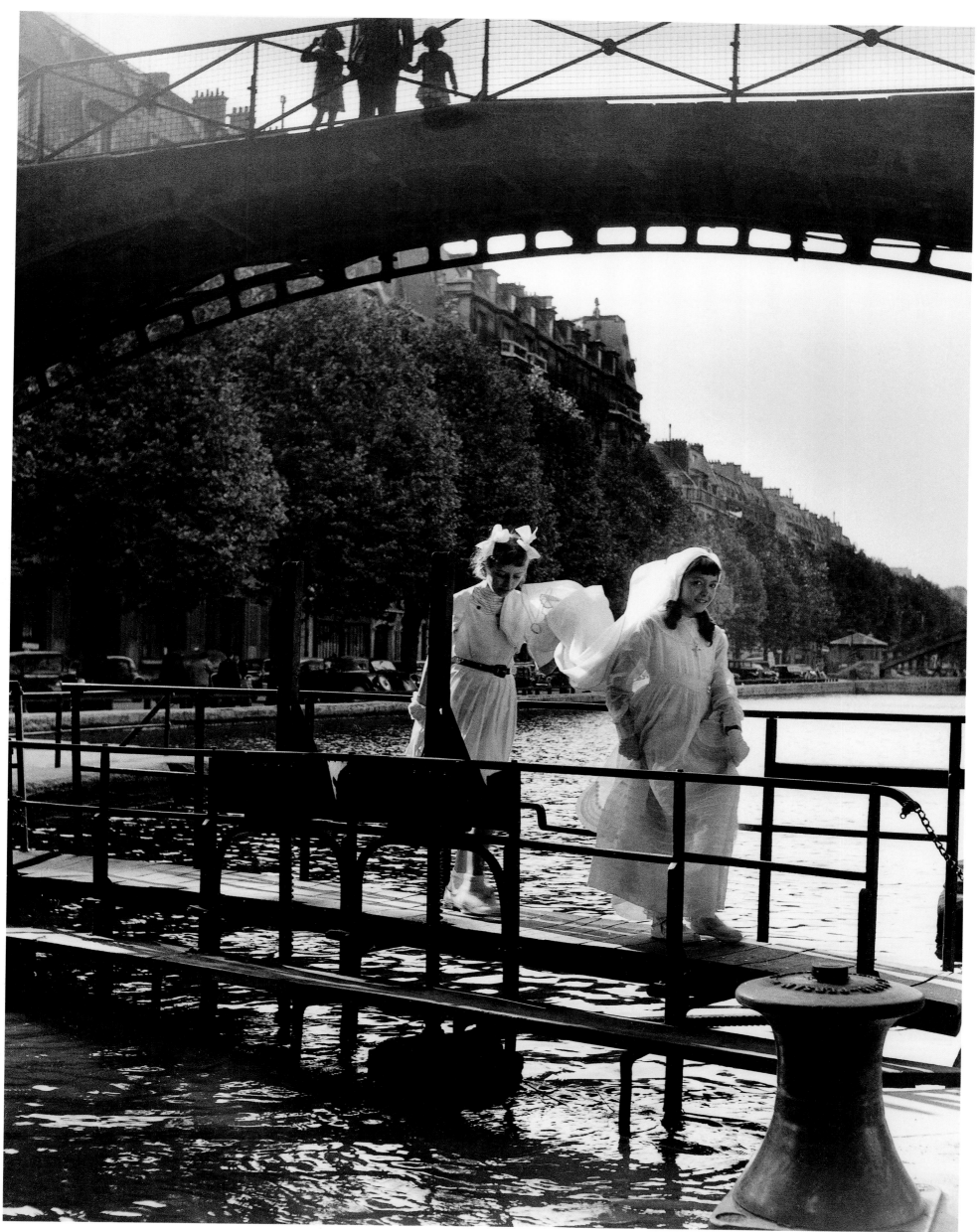

로베르 두아노 **카날 생마르탱**, 1953년

Robert Doisneau
Canal Saint-Martin, Paris 1953
카날 생마르탱
セントマーチン運河

"Paris is a theatre where you book your seat by wasting time. And I'm still waiting".

„Paris ist ein Theater, in dem man seinen Platz mit verlorener Zeit bezahlt. Und ich warte weiter."

« Paris est un théâtre où l'on paye sa place avec du temps perdu. Et j'attends encore. »

"파리는 흘려보내는 시간으로 좌석을 예약하는 극장이다. 그리고 나는 여전히 기다리는 중이다."

「パリは時間を浪費することで予約席ができる劇場なんだ。そして私はいまだに待っているのさ」

ROBERT DOISNEAU

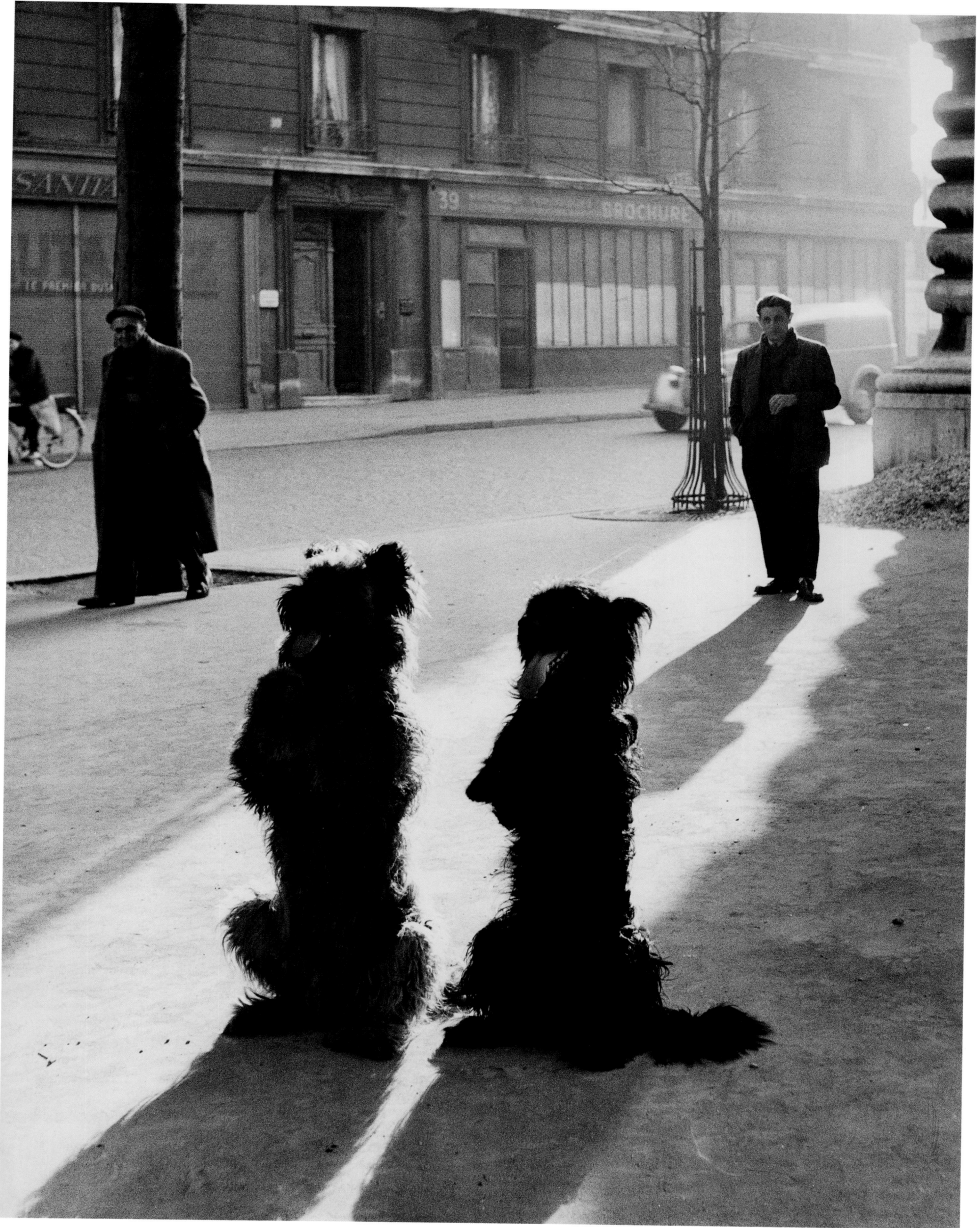

로베르 두아노 샤펠가(街)의 개, 1953년

Robert Doisneau
Dogs, Rue de la Chapelle, Paris 18ᵉ, 1953
Die Hunde von La Chapelle
Les chiens de la Chapelle
샤펠가(街)의 개
犬たち

"Humour is a form of modesty, a way of not describing things, of touching on them delicately,
with a wink. Humour is both mask and discretion, a shelter where one can hide."

„Humor ist eine Form von Scham, eine Weise, die Dinge nicht direkt zu beschreiben,
sie mit Vorsicht anzusprechen, jedoch mit einem Augenzwinkern. Humor ist zugleich
Maskierung und Diskretion, ein Schutzraum, in dem man sich versteckt."

« L'humour c'est une forme de pudeur, une façon de ne pas décrire les choses,
de les aborder avec délicatesse, en donnant un clin d'œil. L'humour est à la fois
masque et discrétion, un abri où l'on se cache. »

"유머는 겸손의 형태로서, 대상을 묘사하는 방법이 아니라
눈짓으로 조심스럽게 대상에게 다가가는 방법이다.
유머는 가면이자 신중함이며, 몸을 숨기는 은신처이다."

「ユーモアとは一種のつつましさだ。物事をあるがままに描かずに、ウィンクをしながら優しく触れることだ。
ユーモアは仮面でもあり用心深さでもあり、逃げ込むことのできる避難所なのだ」

ROBERT DOISNEAU

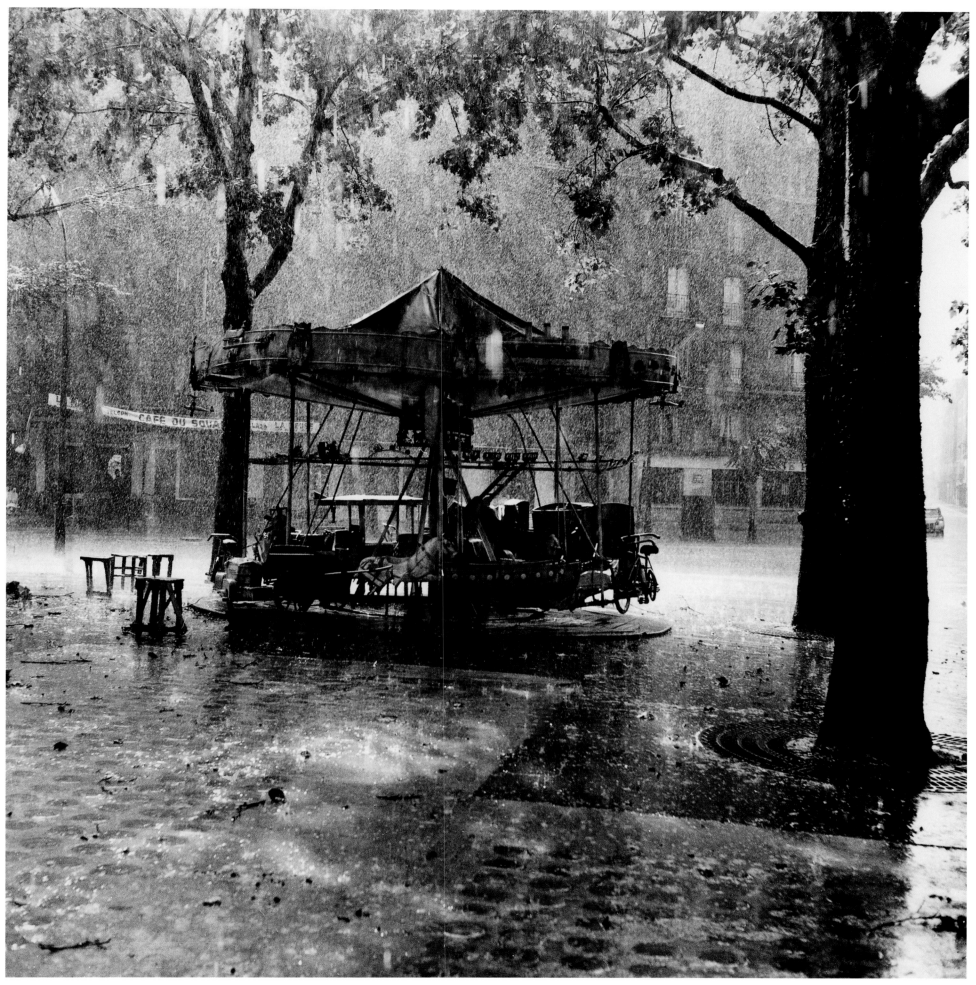

로베르 두아노 바레씨의 회전목마, 1955년

Robert Doisneau
M. Barré's Merry-Go-Round, Place de la Mairie, Paris 14ᵉ, 1955
Das Karussell von Monsieur Barré
Le manège de Monsieur Barré
바레씨의 회전목마
バレーさんのメリーゴーランド

"I've begun to wander about the streets again, to see at last the people and the scenery. It's only a reprieve, but optically I'm guzzling it in … I am looking for some kind of good fortune".

„Ich begann wieder durch die Straßen zu laufen, sozusagen als Ausgleichsbeschäftigung, aber mit den Augen habe ich alles verschlungen …"

« J'ai recommencé à traîner dans les rues et les décors, c'est un sursis mais je gloutonne optiquement … Je suis à la recherche d'une sorte de bonheur. »

"사람들과 풍경을 보기 위해 다시 주변 거리를 산책하기 시작했다.
잠깐의 유예에 불과하지만, 나는 눈으로 마음껏 받아들였다……. 나는 행운을 찾는 중이다."

「ようやく人々や風景を見に、再び路上散策に戻った。しばしの休憩に過ぎなかったのだが、
私は自分のための撮影に没頭した。私はある種の幸運を求めているのだ」

ROBERT DOISNEAU

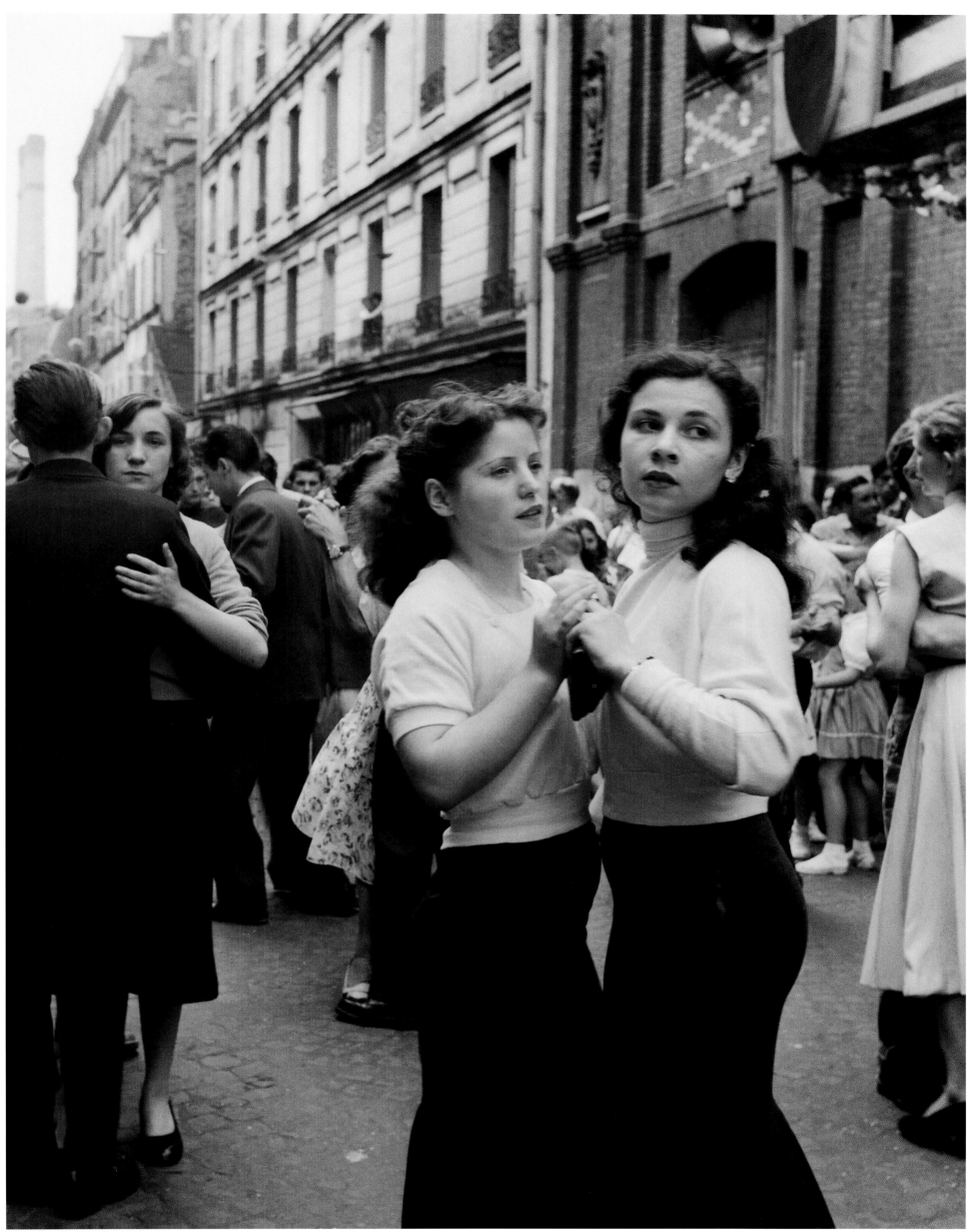

로베르 두아노 **7월 14일**, 1955년

Robert Doisneau
14 Juillet, Rue de Nantes, Paris 19ᵉ, 1955
Die Ausbuchtungen
Les Ventres du 14 juillet
7월 14일
7月14日

"Of course, I did what I did deliberately. It was intended, but I certainly had no thought of making a corpus with it, I simply wanted to leave a memory of the little world that I loved".

„Sicherlich, was ich gemacht habe, habe ich bewusst gemacht. Es war gewollt, aber ich habe gewiss nicht daran gedacht, ein Werk zu schaffen, ich wollte lediglich die Erinnerung an diese kleine Welt zurücklassen, die ich liebte."

« Bien sûr, ce que je faisais, je le faisais exprès. C'était voulu, mais je ne pensais certainement pas à en faire une œuvre, je voulais simplement laisser le souvenir de ce petit monde que j'aimais. »

"물론, 나는 일부러 그렇게 했다. 의도적으로 그러기는 했지만, 정말로 그것을 작품으로 만들 생각은 없었다. 나는 단지 내가 사랑하는 이 작은 세계에 관한 추억을 남기고 싶었을 뿐이다."

「もちろん、したことはすべて意図的だったさ。でもそれで全集を出そうなどと思ったことはなかった。私が愛した小さな世界の記憶を残しておきたかっただけなんだ」

ROBERT DOISNEAU

© 2006 TASCHEN GmbH
Hohenzollernring 53, D-50672 Köln
www.taschen.com
© 2004 Atelier Robert DOISNEAU

Korean Translation © 2006 Maroniebooks, Seoul
www.maroniebooks.com

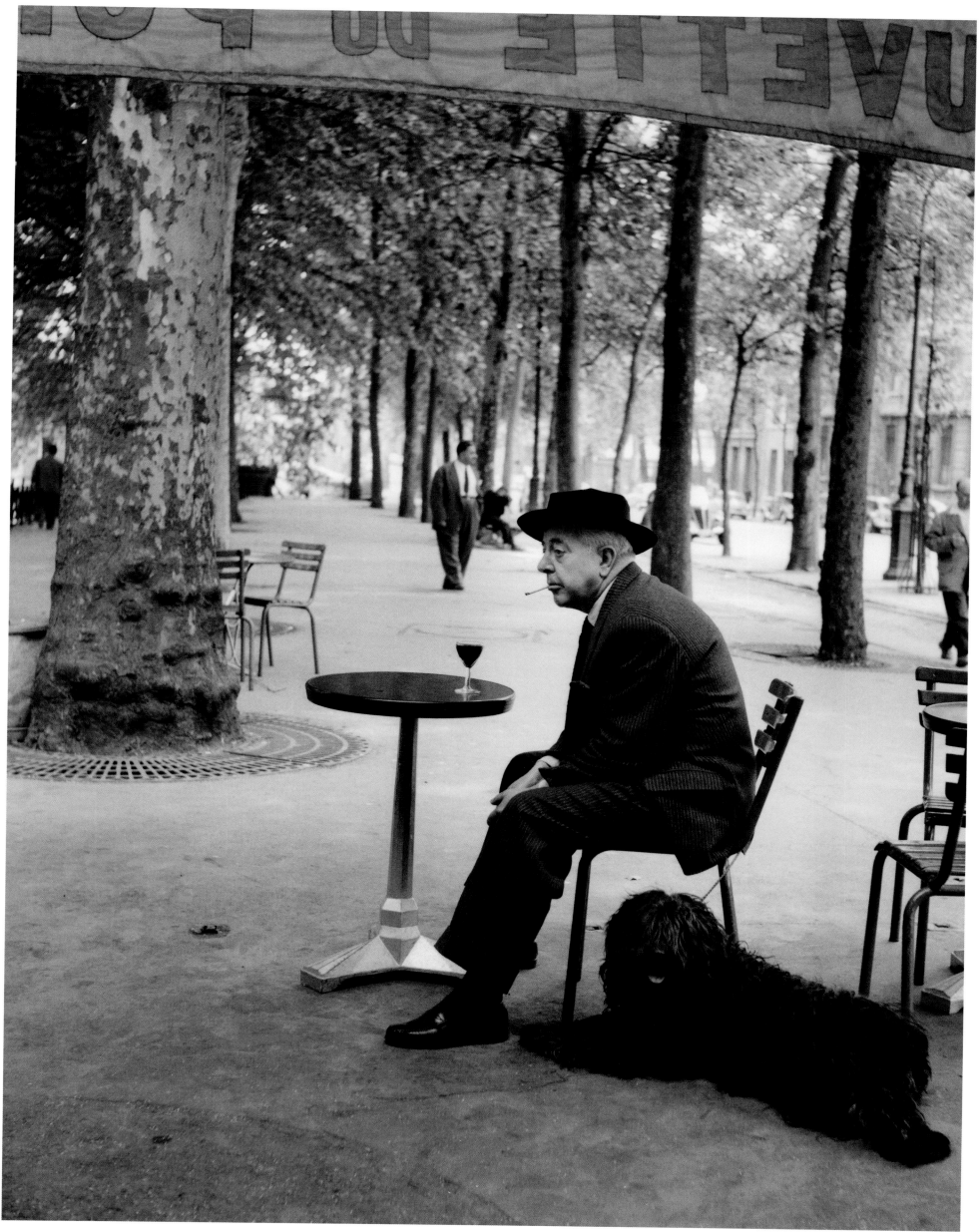

로베르 두아노 원형 탁자 앞의 프레베르, 1955년

Robert Doisneau
Prévert at a Café Table, Quai Saint-Bernard, Paris 5ᵉ, 1955
Prévert am Bistro-Tisch
Prévert au guéridon
원형 탁자 앞의 프레베르
カフェテーブルのプレヴェール

"I have often taken photos of people just standing still, people willing to be taken who stare
into the lens. I realised that these people so simply portrayed were often more eloquent like that
than caught in mid-gesture. It leaves the onlooker space to imagine!".

„Ich habe häufig Fotografien von unbewegt dastehenden Personen gemacht, die bereitwillig in
die Linse blickten ... Ich habe festgestellt, dass diese Aufnahmen sehr viel mehr aussagten, als wenn
ich die Leute beim wilden Gestikulieren aufgenommen hätte. So hat der Betrachter die
Möglichkeit, seine Fantasie spielen zu lassen."

« J'ai souvent pris des photographies de personnages immobiles, de personnages
consentants qui regardaient l'appareil. Je me suis aperçu que ces personnages bêtement
photographiés en disaient beaucoup plus qu'en les saisissant en pleine gesticulation.
Cela donne au spectateur la possibilité d'imaginer. »

"나는 가만히 서 있는 사람들, 기꺼이 사진기를 바라봐주는 사람들을 자주 찍었다.
나는 이 사람들의 꾸밈없는 모습을 찍은 사진이 한껏 제스처를 취한 사람들의 사진보다
더 많은 이야기를 한다는 것을 깨달았다. 그런 사진은 보는 사람에게 상상의 여지를 준다."

「ただじっと立っているだけの人たちの写真も数多く撮った。レンズを見つめ、進んで撮られようとしてくれる
人たちを。こういった実に素朴に撮られた人々は、身振りをしている最中に写した人たちよりも、より雄弁に
語りかけていることに気づいた。その方が見る者に想像力をかき立てる余地を与えてくれるからだ」

ROBERT DOISNEAU

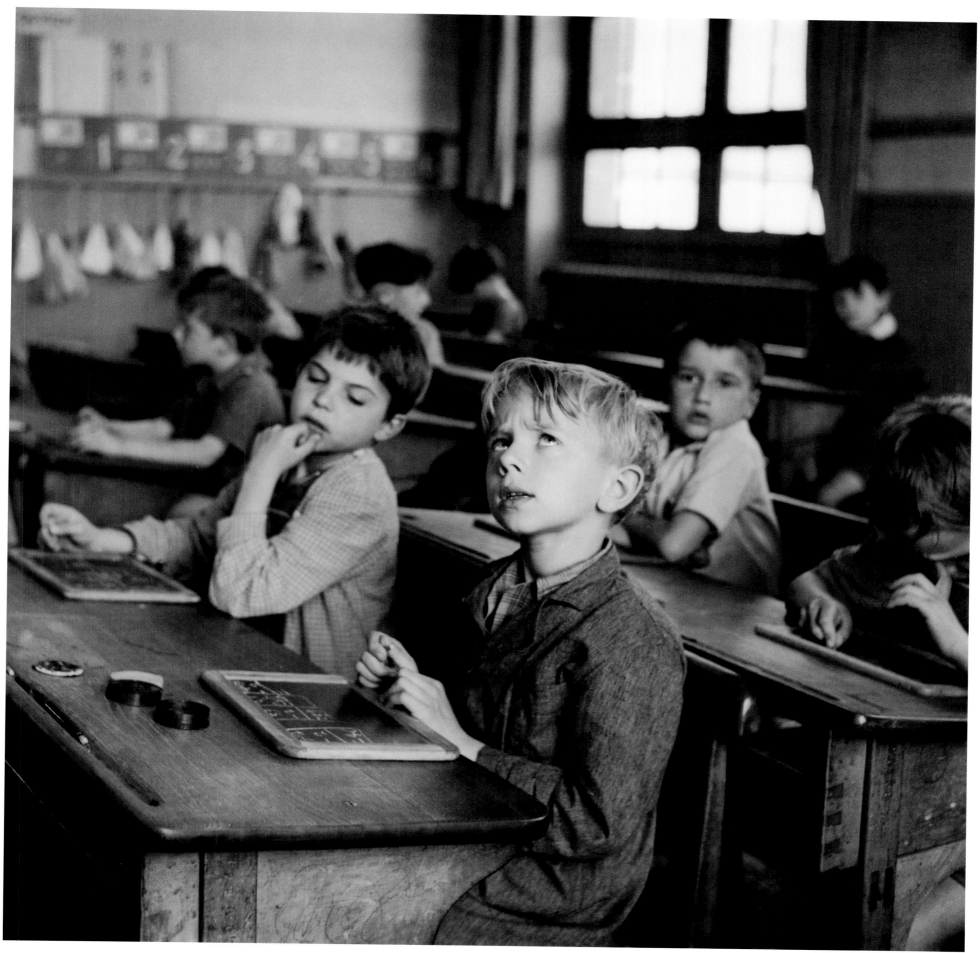

로베르 두아노 **정답을 찾아서**, 1956년

Robert Doisneau
Close to the Right Answer, Paris 5ᵉ, 1956
Beim Unterricht
L'information scolaire
정답을 찾아서
正解間近

"I took a mischievous pleasure in spotlighting society's rejects,
in both the people I took and my choice of background."

„Ich habe ein diebisches Vergnügen daran, die zu kurz Gekommenen
in den Mittelpunkt zu rücken, und das gilt sowohl für die Menschen als auch
für die Auswahl der Umgebung."

« J'ai pris un malin plaisir à mettre en lumière les laissés-pour-compte,
aussi bien parmi les humains que dans le choix des décors. »

"인물을 찍거나 배경을 선택할 때,
세상에서 소외된 것에 스포트라이트를 비추면 나는 개구쟁이처럼 즐거워진다."

「社会に拒否されたものにスポットライトを当てることに、いたずらじみた喜びを感じるんだ。
見捨てられたというのは、私が撮る人々のことでもあるし、背景のことでもある」

ROBERT DOISNEAU

© 2006 TASCHEN GmbH
Hohenzollernring 53, D-50672 Köln
www.taschen.com
© 2004 Atelier Robert DOISNEAU

Korean Translation © 2006 Maroniebooks, Seoul
www.maroniebooks.com

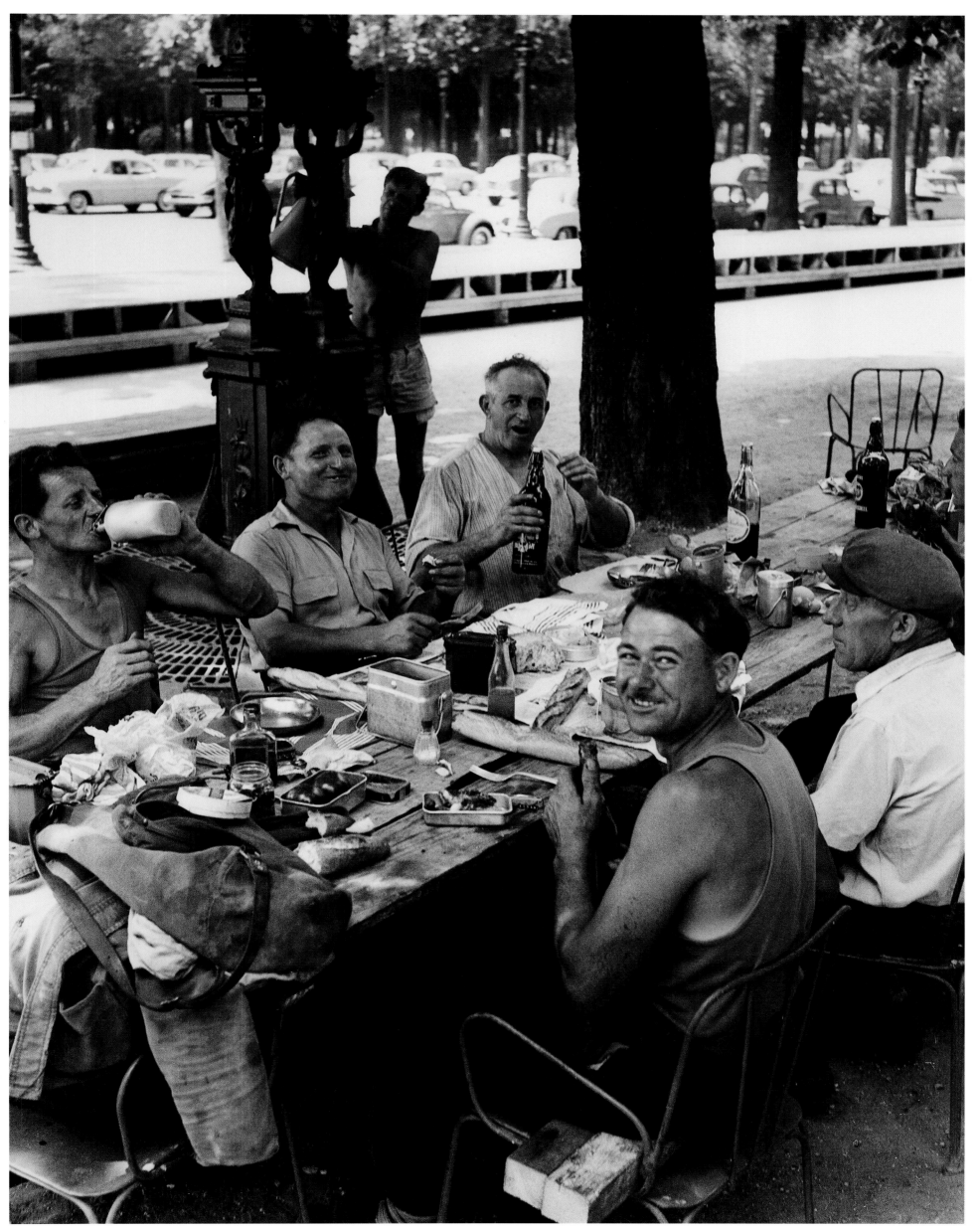

로베르 두아노 **샹젤리제**, 1959년

Robert Doisneau
Champs-Élysées, Paris 8ᵉ, 1959
샹젤리제
広場―エリゼ宮

"One of the great joys of my career has been to see and speak to people I don't know. Very often
these simple people are the sweetest souls and generate an atmosphere of poetry all by themselves."

„Eine der größten Freuden meiner Karriere ist es, mit Leuten zu sprechen,
die ich zuvor nicht gekannt habe. Häufig stellen sich diese einfachen Leute als
einfühlsame Menschen heraus, die ein poetisches Klima schaffen."

« Une des grandes joies de ma carrière c'est de voir, de parler à des gens
que je ne connais pas. Bien souvent ces gens simples se trouvent être des personnages
délicieux qui déclenchent un climat poétique. »

"내 일의 커다란 즐거움 중 하나는 모르는 사람들을 만나고 그들에게 말을 거는 것이다.
대체로 이 순박한 사람들은 참 친절했으며, 자연스럽게 시적인 분위기를 풍겼다."

「私のキャリアで一番の喜びは、見知らぬ人と会って話をすることだった。
ほとんどいつでも、こういった人たちは実に優しく、自然と詩的な雰囲気を漂わせていた」

ROBERT DOISNEAU

© 2006 TASCHEN GmbH
Hohenzollernring 53, D-50672 Köln
www.taschen.com
© 2004 Atelier Robert DOISNEAU

Korean Translation © 2006 Maroniebooks, Seoul
www.maroniebooks.com

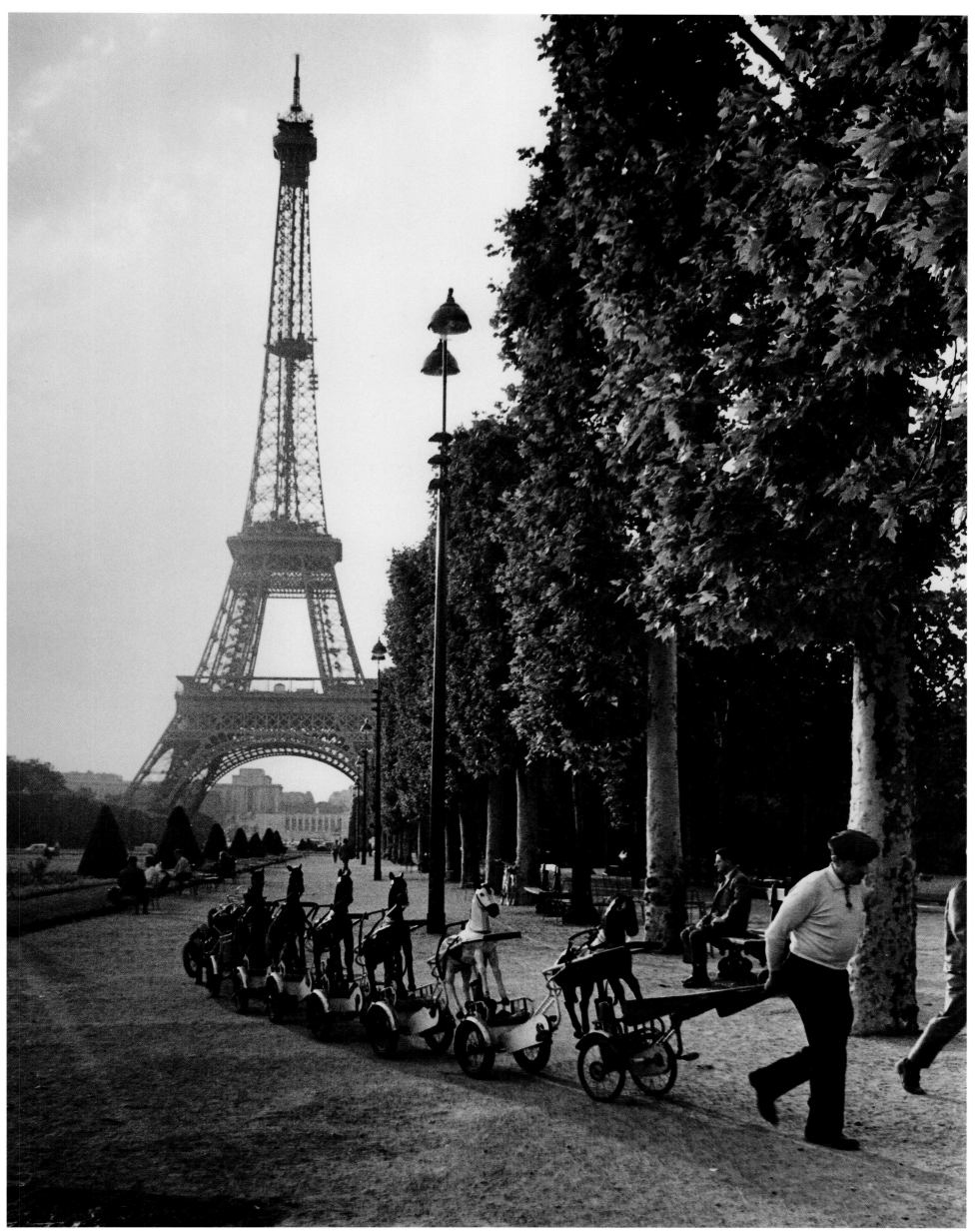

로베르 두아노 샹 드 마르스의 기병대, 1969년

Robert Doisneau
Cavalry on the Champ-de-Mars, Paris 7ᵉ, 1969
Die Kavallerie vom Champ-de-Mars
La cavalerie du Champ-de-Mars
샹 드 마르스의 기병대
シャン・ドゥ・マルの騎兵隊

"Life is by no means happy, but we still have humour, a sort of hiding-place
in which the emotion that we feel is imprisoned".

„Das Dasein ist sicherlich nicht komisch, aber dafür haben wir den Humor,
dieses Schlupfloch, wo man seine Emotionen zügeln kann."

« L'existence n'est certes pas gaie, mais il nous reste l'humour,
cette espèce de cachette où l'on jugule l'émotion ressentie. »

"삶은 물론 즐겁지 않다. 하지만 우리에겐 아직 유머가 있다.
유머는 우리가 느끼는 감정을 가둬놓는 일종의 은닉처이다."

「人生は決して楽しいばかりじゃない。それでも我々にはユーモアの心がある。
我々が感じる感情が閉じ込められている隠れ家のようなものだ」

ROBERT DOISNEAU

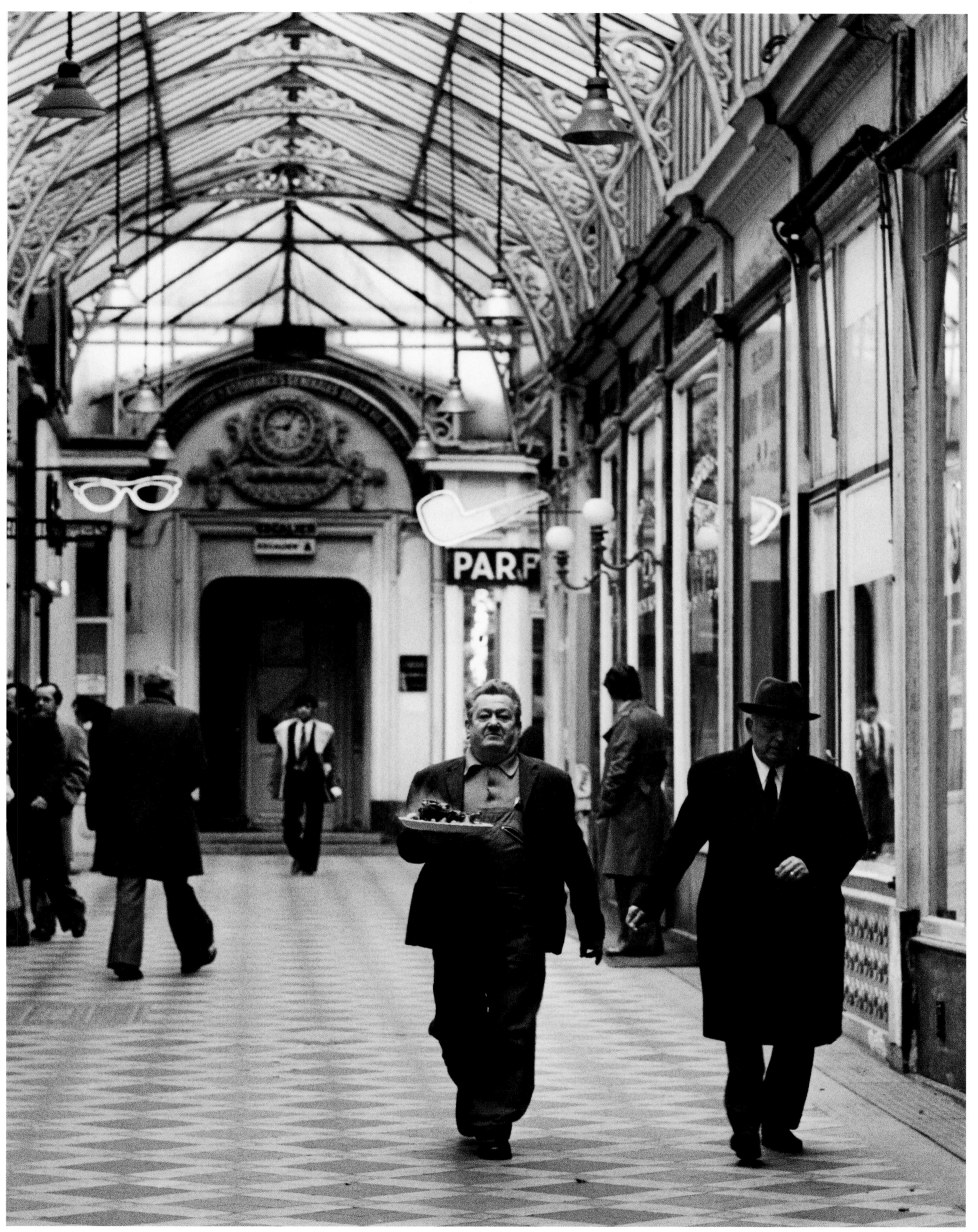

로베르 두아노 파사주 데 프랭스, 1976년

Robert Doisneau
Passage des Princes, Paris 2ᵉ, 1976
파사주 데 프랭스
パッサージュ・デ・プランス

"My little universe, which has not been much photographed, has taken on such
an exotic aspect that it is now the preserve of astonishing life-forms. They don't make me laugh,
not at all ... even though I have a profound desire to keep myself entertained, and have been
entertained, all my life. I have made a little theatre for myself".

„Mein kleines Universum, das nur von wenigen Leuten fotografiert worden ist, zeigt
sich von einer dermaßen exotischen Seite, dass es zur unerschöpflichen Quelle einer höchst
erstaunlichen Typenwelt wird. Sie bringen mich jedoch keineswegs zum Lachen ... selbst wenn
ich persönlich eine Riesenlust habe, mich zu amüsieren, und ich habe mich mein Leben
lang amüsiert. Ich habe mir ein kleines Theater geschaffen."

« Mon petit univers, photographié par peu de personnes, prend un aspect tellement
exotique qu'il devient la réserve d'une faune étonnante. Moi, ils ne me font pas rire du tout ...
Même si j'ai personnellement une profonde envie de m'amuser, et toute ma vie je me suis
amusé, je me suis fabriqué un petit théâtre. »

"다른 사람이 거의 찍은 적이 없는 나의 작은 우주는 너무도 매혹적이어서
여러 가지 놀라운 생활 형태의 보호구역이 되었다. 나는 그것을 보고 웃지 않는다.
나는 늘 즐거움에 대한 욕망을 갖고 있었고 또 평생 즐겁게 살아왔지만, 결코 그것을 보고 웃지 않는다.
나는 나를 위해 작은 극장을 만들었다."

「私の小宇宙はこれまで写真に撮られたことはあまりなかったが、今や極めて風変わりな様相を帯びており、
驚くべき生命体の保護区になってしまったほどだ。それを見ても私は笑えない。ぜんぜん笑えない。
私はいつでも楽しませてもらうことを望んでいるし、生涯楽しんできたというのに。
私は自分のための小劇場を作った」

ROBERT DOISNEAU